D1097778

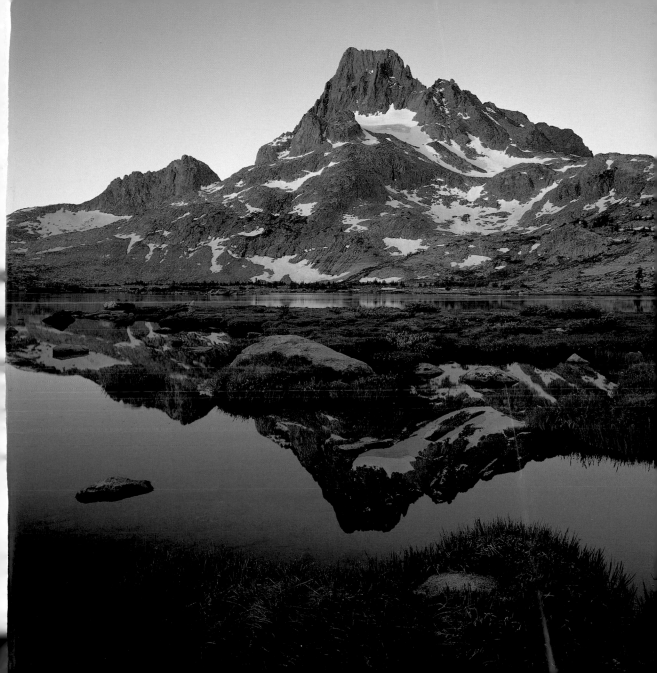

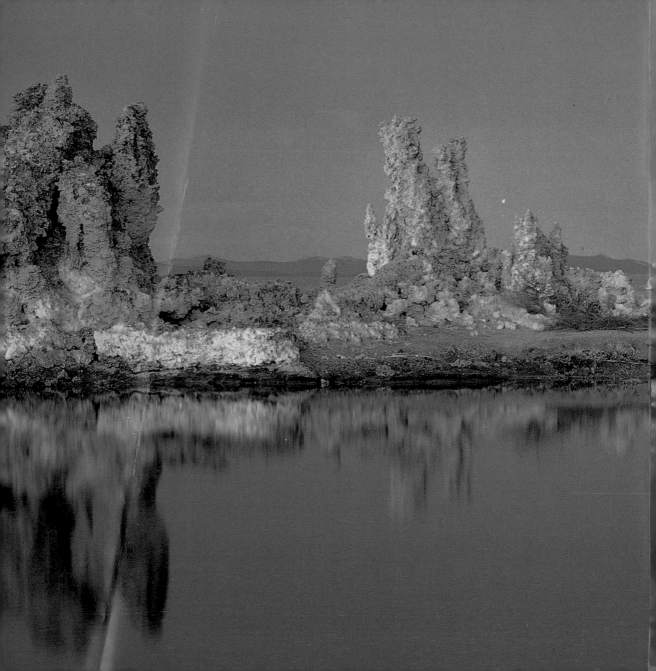

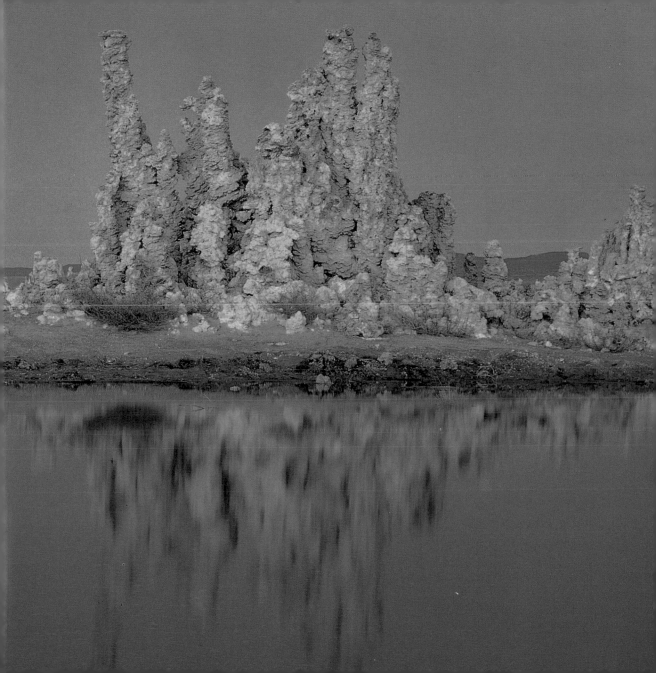

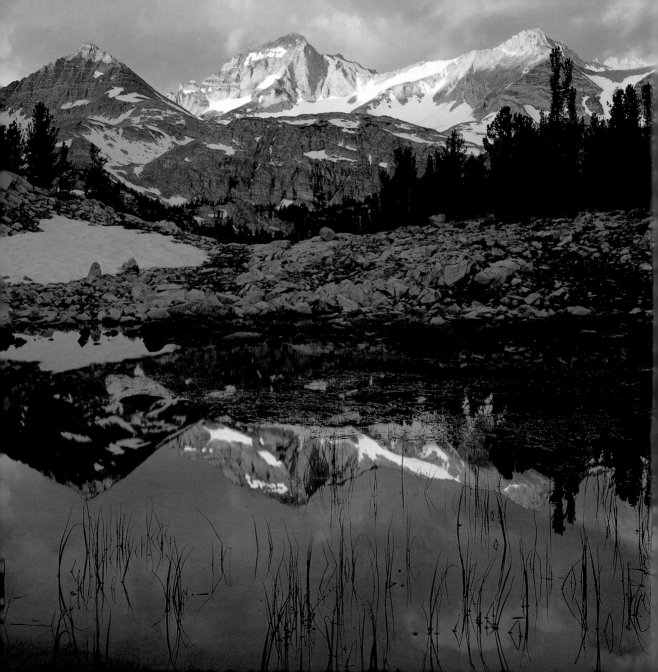

CALIFORNIA REFLECTIONS

Photography by Carr Clifton
With Selected Prose & Poetry

California Littlebooks

Westcliffe Publishers, Inc., Englewood, Colorado

First frontispiece: Banner Peak, Ansel Adams Wilderness
Second frontispiece: Tufa formations, Mono Lake
Third frontispiece: Bear Creek Spire, John Muir Wilderness
Opposite: Big Sur Coast

International Standard Book Number: 1-56579-135-5
Library of Congress Catalog Number: 95-62433
Copyright Carr Clifton, 1996. All rights reserved.
Published by Westcliffe Publishers, Inc.
2650 South Zuni Street, Englewood, Colorado 80110
Publisher, John Fielder; Editor, Suzanne Venino; Designer, Amy Duenkel
Printed in Hong Kong by Palace Press

No portion of this book, either photographs or text, may be reproduced
in any form without the written permission of the publisher.

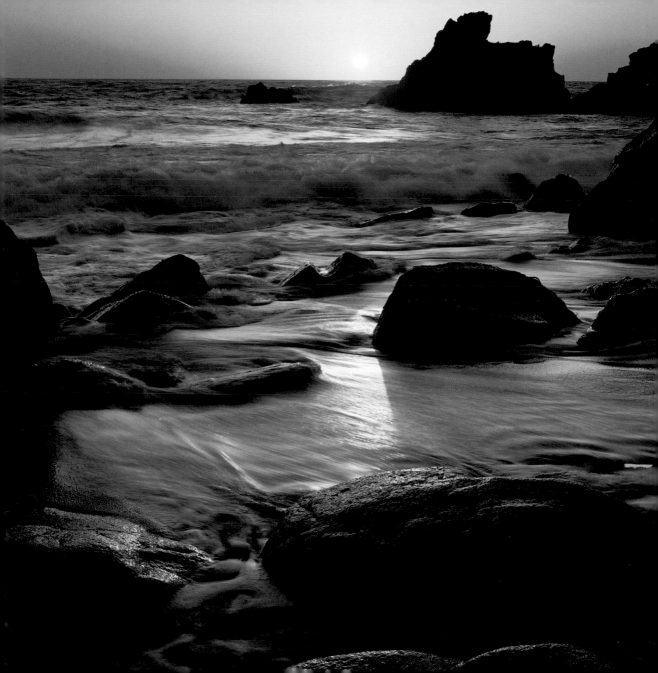

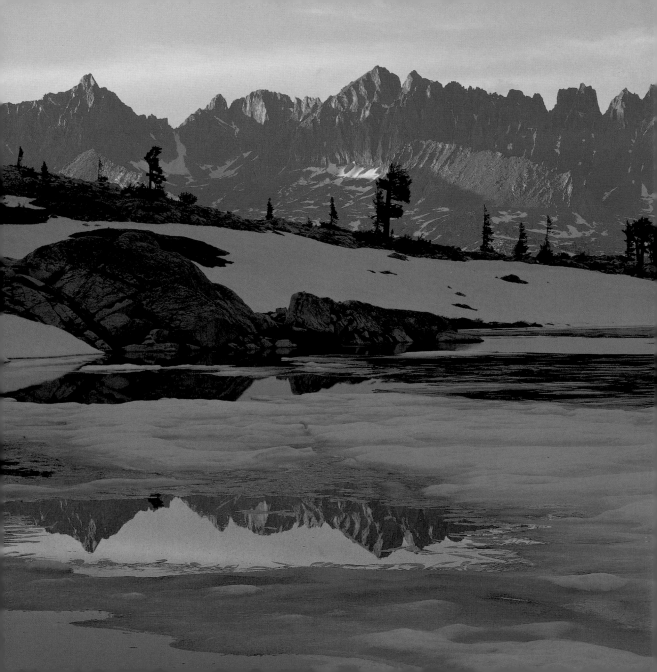

PREFACE

"Among the many unlooked-for treasures that are bound up and hidden away in the depths of Sierra solitudes, none more surely charm and surprise all kinds of travelers than the glacier lakes," wrote John Muir in his book, *The Mountains of California* (1894). "The forests and the glaciers and the snowy fountains of the streams advertise their wealth in a more or less telling manner even in the distance, but nothing is seen of the lakes until we have climbed above them. All the upper branches of the rivers are fairly laden with lakes, like orchard trees with fruit. They lie embosomed in the deep woods, down in the grovy bottoms of canyons, high on bald tablelands, and around the feet of the icy peaks, mirroring back their wild beauty over and over again."

The lakes, ponds, and alpine tarns of the Sierra Nevada provide infinite variations of reflections — reflections of snowcapped mountain peaks, cloud patterns in still blue waters, the rosy shades of evening painting a liquid sunset. In a state as large and diverse as California, you can find reflections just about everywhere. Coastal waters and desert flats, as well as the mountain lakes, hold a mirror to the landscape.

The calm surface of water can mimic a near duplicate image of the surrounding scenery, often making it difficult to tell which is the real image and which is the reflected one. The resulting photographs are beautiful as well as thought provoking, for reflection photographs turn the world upside down, showing nature from a new perspective and giving free rein to the imagination.

Kaweah Peaks, Sequoia National Park

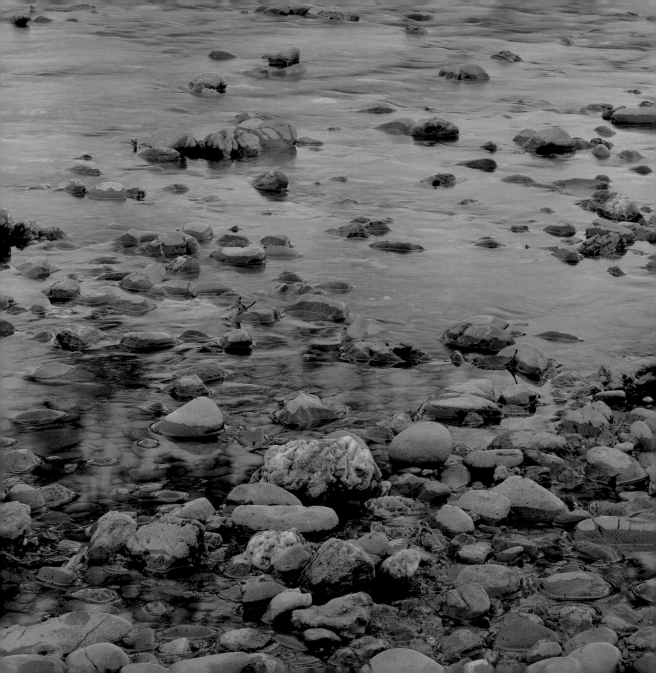

The sharpest, most vivid reflection photographs are made when the water is still. Mornings and evenings are the best time to photograph reflections in the high country, for mountain weather is generally calm then and the waters undisturbed. Wind and weather stir the water's surface, breaking up the image into refracted bits and pieces. Yet even this can make an artful photograph, creating an impressionistic effect, like a painting by Monet.

Just about any body of water, from ocean waves to a lowly puddle, will reflect the light of dawn and dusk—magical moments of the day that streak the sky with shades of red, purple, and orange. More than just pretty pictures, sunrise and sunset scenes instill a sense of tranquility, often evoking an emotional response from the viewer.

Carr Clifton's photographs always evoke an emotional response. His images of the landscape portray the very best of the natural world, creating with a two-dimensional sheet of film the same wonder and awe that John Muir expressed in words more than a century ago. The reflection photographs illustrated in the pages of this book capture the scenic splendor of California's landscapes, "mirroring back their wild beauty over and over again."

— Suzanne Venino
Editor

Rocks in Redwood Creek, Redwood National Park

"To see clearly is poetry, prophecy,
and religion — all in one."

— John Ruskin, *Modern Painters*

Indian paintbrush by Chickenfoot Lake,
John Muir Wilderness

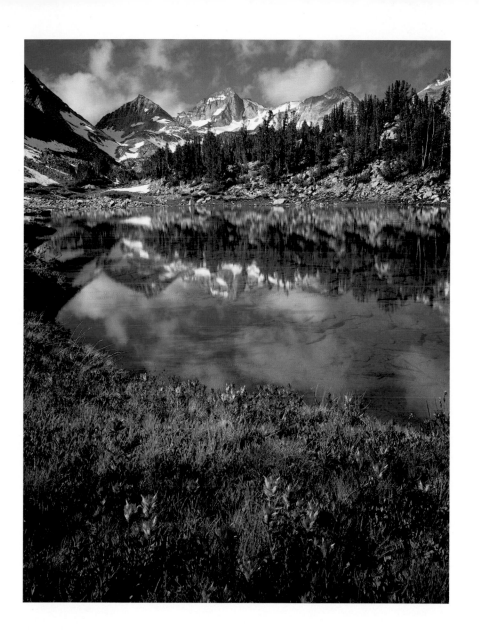

"We do not receive wisdom, we have to discover it for ourselves by a voyage that no one can take for us..."

— Marcel Proust, *Remembrance of Things Past*

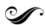

Morning light on Indian Creek, Plumas National Forest

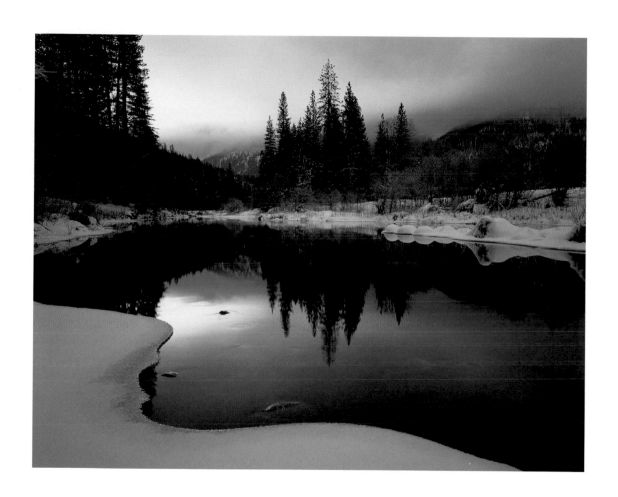

"Solitude...is essential to any depth of
meditation or of character; and solitude in the
presence of natural beauty and grandeur,
is the cradle of thoughts and aspirations..."

— John Stuart Mill, *Principles of Political Economy*

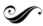

Sunrise over Drakes Bay, Point Reyes National Seashore

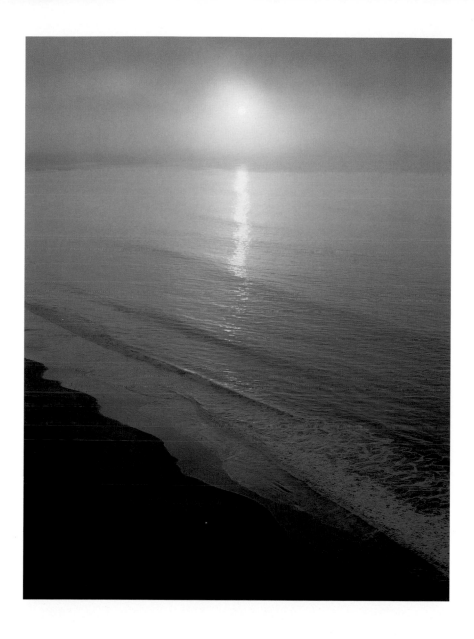

"A rock pile ceases to be a rock pile the moment a single man contemplates it, bearing within him the image of a cathedral."

— Antoine de Saint-Exupery, *Flight to Arras*

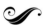

Muriel Peak, John Muir Wilderness

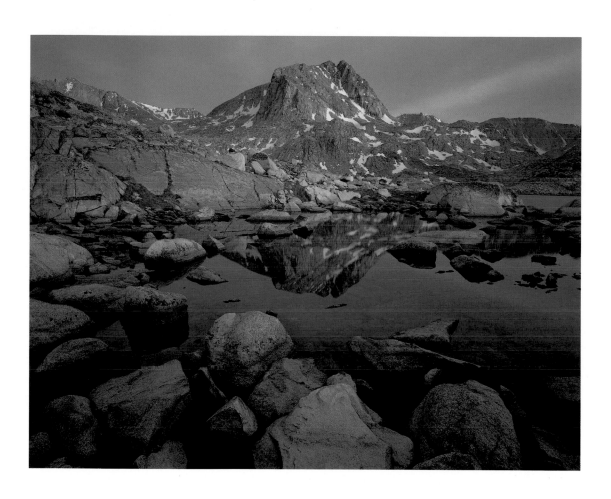

"Nature is an endless combination and repetition of a
very few laws. She hums the old well-known air
through innumerable variations."

— Ralph Waldo Emerson, *Essays*

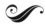

Ansel's Wall rises above Precipice Lake, Sequoia National Park

Overleaf: Frosted grasses, Tuolumne Meadows, Yosemite National Park

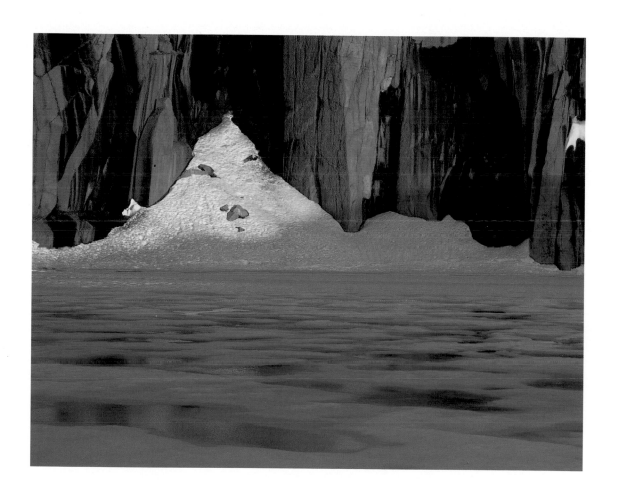

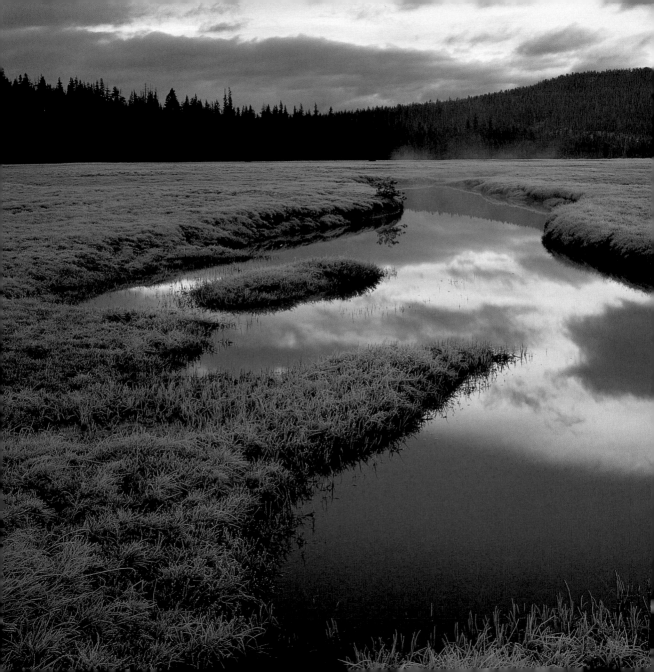

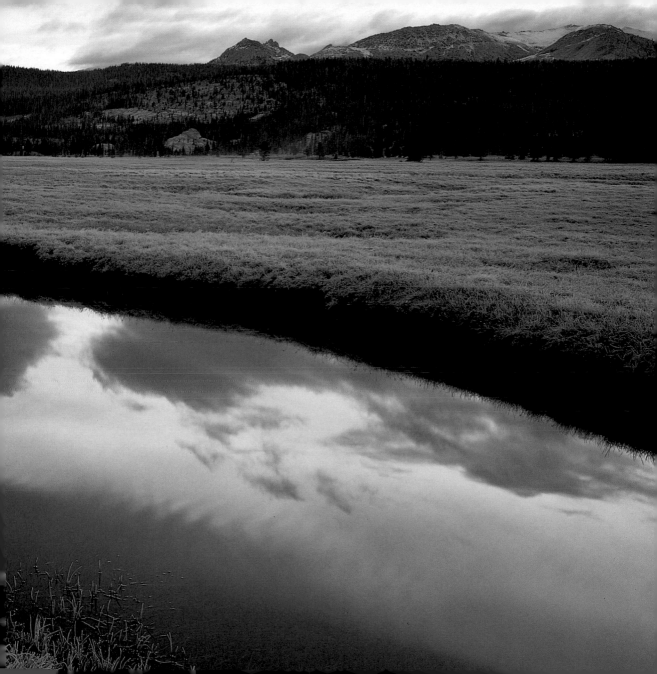

"Every situation — nay, every moment — is of
infinite worth, for it is the representative
of a whole eternity."

— Goethe, in Eckermann's *Conversations*

Isosceles and Columbine Peaks,
Kings Canyon National Park

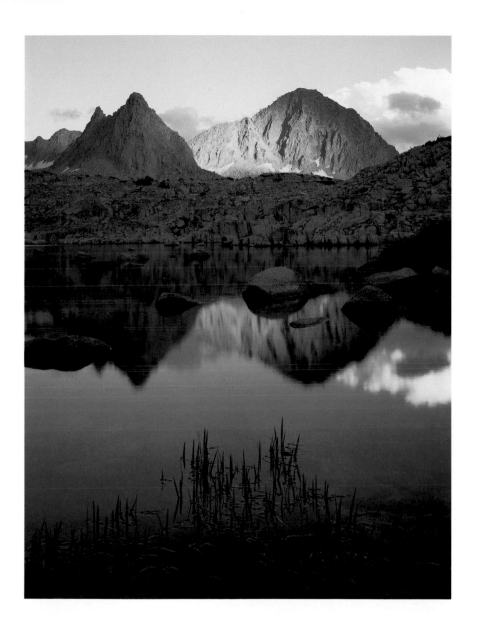

"How often we forget all time, when lone
Admiring Nature's universal throne
Her woods, her wilds, her waters intense
Reply of hers to our intelligence."

— Lord Byron, *The Island*

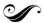

Sunset, Trinidad State Beach

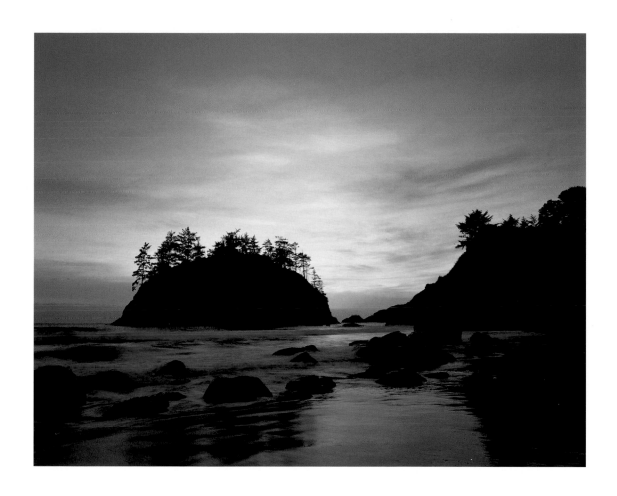

"Everything that happens happens as it should,
and if you observe carefully, you will find this to be so."

— Marcus Aurelius, *Meditations*

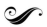

Autumn leaves, Lights Creek, Plumas National Forest

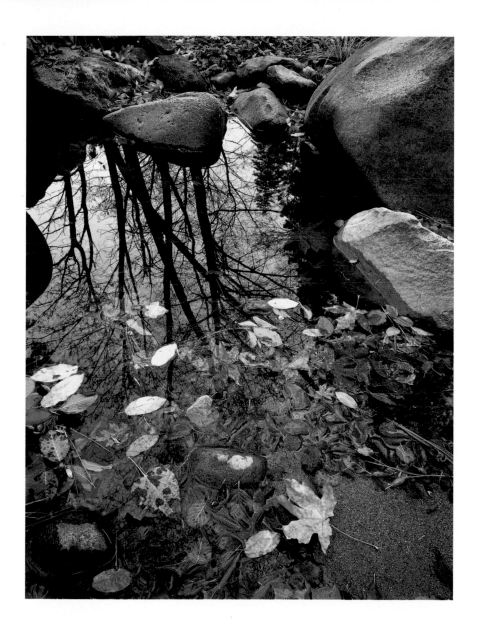

"In Nature's infinite book of secrecy,

A little I can read."

— Shakespeare, *Antony and Cleopatra*

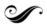

The Black Mountains rise above Devil's Golf Course,
Death Valley National Park

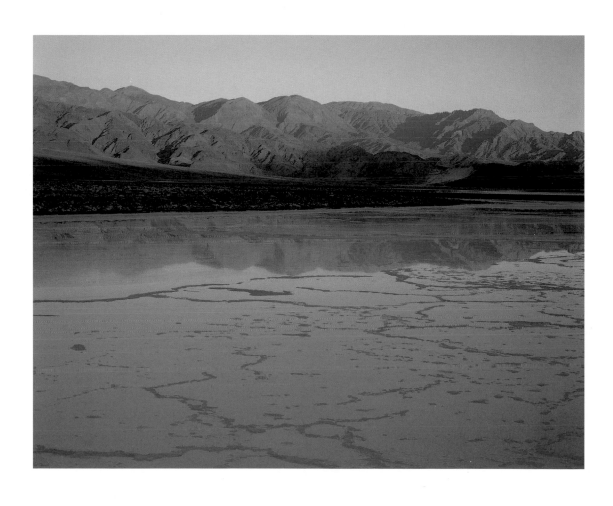

"To the attentive eye, each moment of the year
has its own beauty…it beholds, every hour,
a picture which was never seen before,
and which shall never be seen again."

— Ralph Waldo Emerson, *Beauty*

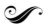

Ice-covered pines along Indian Creek, Plumas National Forest

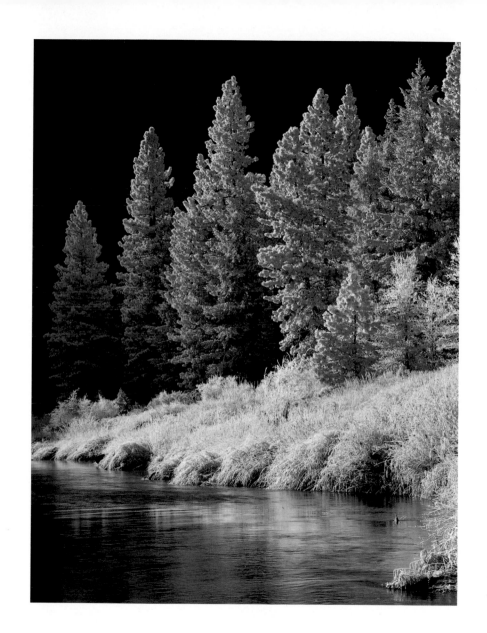

"To him who in the love of Nature holds
Communion with her visible forms, she speaks
A various language."

— William Cullen Bryant, *Thanatopsis*

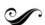

Eagle Crest reflects in an alpine tarn,
Sequoia National Park

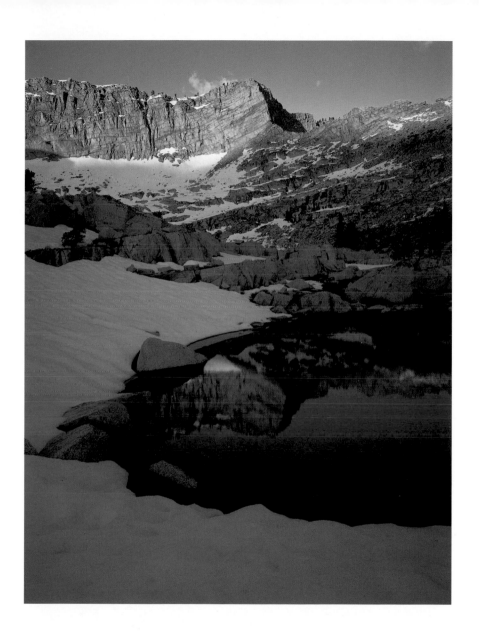

"The day, water, sun, moon, night — I do not have
to purchase these things with money."

— Titus Maccius Plautus, *The Comedy of Asses*

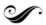

Sunset on Cardiff State Beach, San Diego County

Overleaf: Darwin Crest reflected in Evolution Creek, Kings Canyon National Park

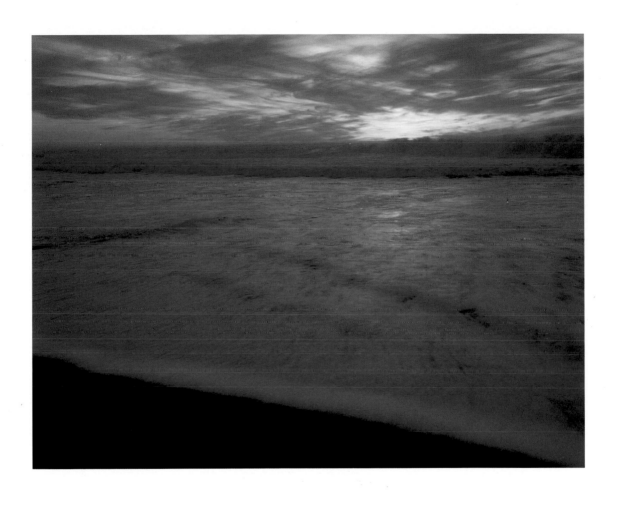

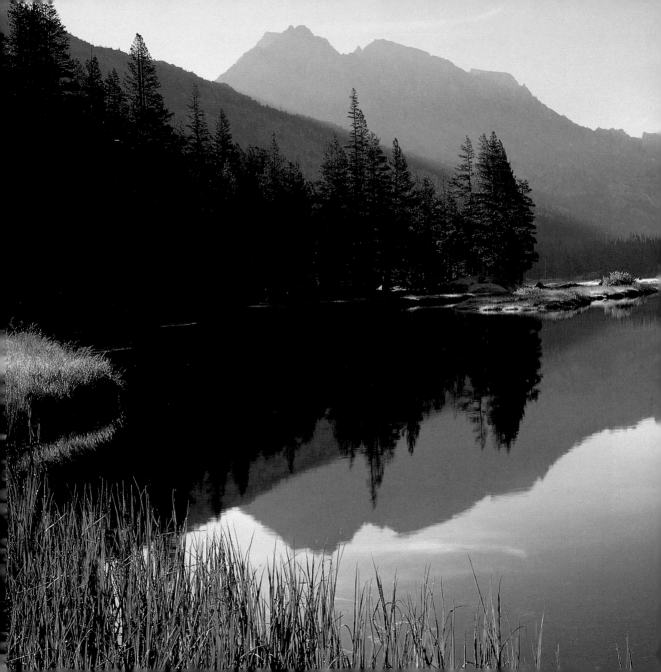

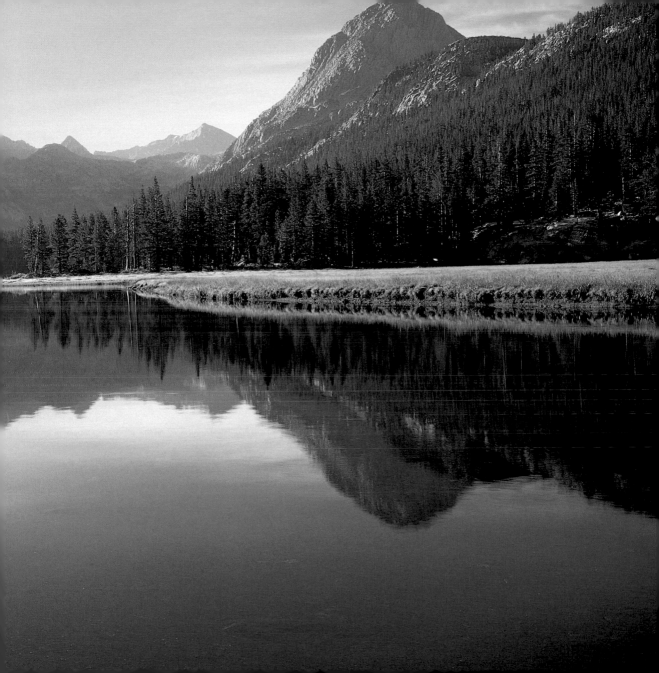

"The whole secret of the study of nature lies in learning how to use one's eyes..."

— George Sand, *Nouvelles Lettres d'un Voyageur*

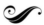

Merriam Peak above Royce Lake, John Muir Wilderness

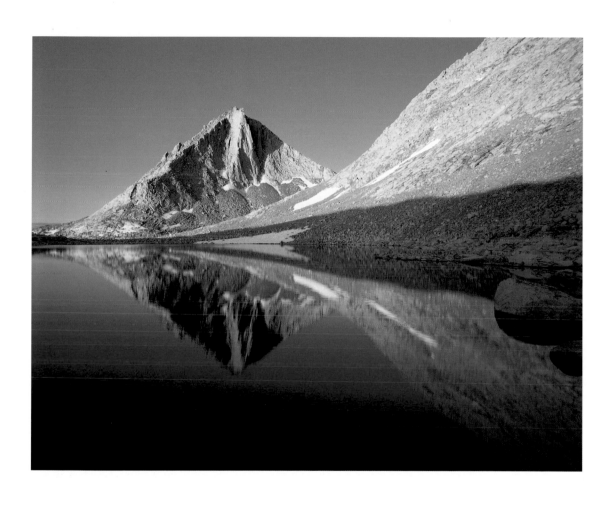

"Nature has presented us with a large faculty of
entertaining ourselves alone...to teach us
that we owe ourselves in part to society,
but chiefly and mostly to ourselves."

— Montaigne, *On Giving the Lie*

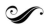

Sunrise, Mono Lake

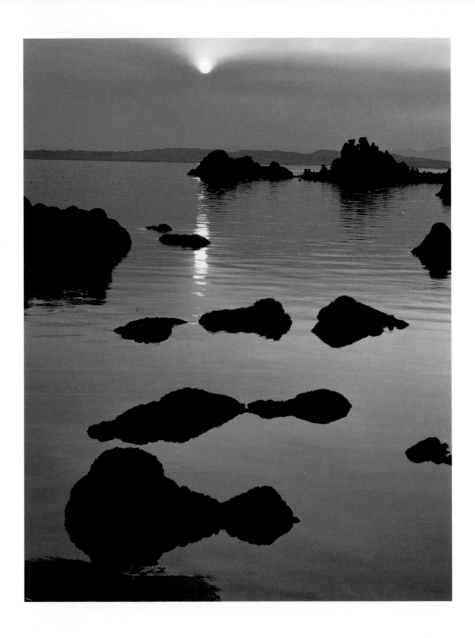

"What would the world be, one bereft
Of wet and of wildness? Let them be left,
O let them be left, wildness and wet;
Long live the weeds and the wilderness yet."

— Gerard Manley Hopkins, *Inversnaid*

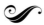

Salt marsh below the Panamint Range, Death Valley National Park

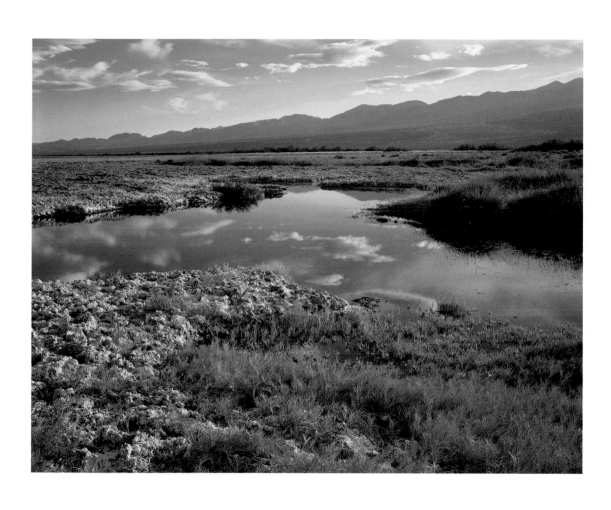

"There is a road from the eye to the heart
that does not go through the intellect."

— G. K. Chesterton, *The Defendant*

Frost-covered grasses beneath Unicorn Peak,
Yosemite National Park

"Surely there is something in the unruffled calm of nature that overawes our little anxieties and doubts; the sight of the deep-blue sky…seems to impart a quiet to the mind."

— Jonathan Edwards, *The New Dictionary of Thoughts*

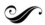

Spring runoff, Tuolumne Meadows,
Yosemite National Park

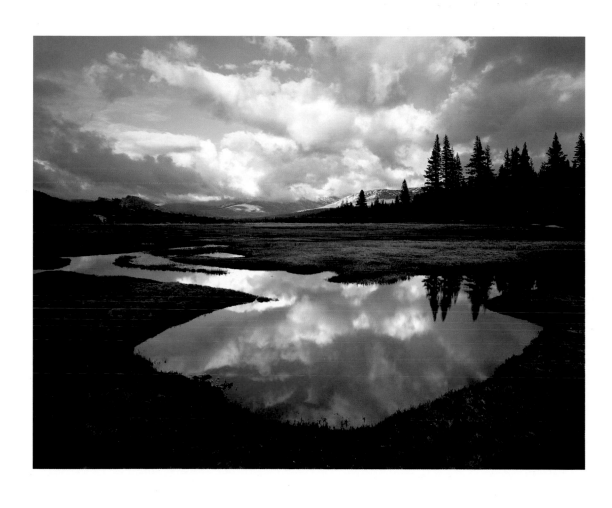

"Everybody needs beauty...places to play in
and pray in where Nature may heal and cheer
and give strength to the body and soul alike."

— John Muir, *Travels in Alaska*

Indian paintbrush below Banner Peak, Ansel Adams Wilderness

"Trees are the earth's endless effort
to speak to the listening heaven."

— Rabindranath Tagore, *Fireflies*

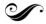

Oak tree, near Red Bluff, northern California foothills

Overleaf: Receding surf, Trinidad State Beach

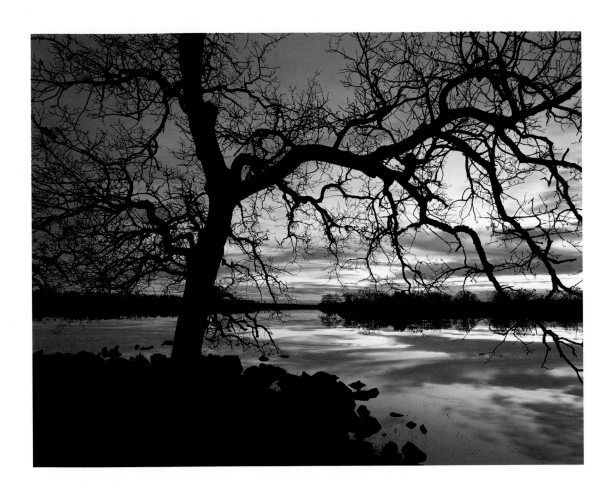

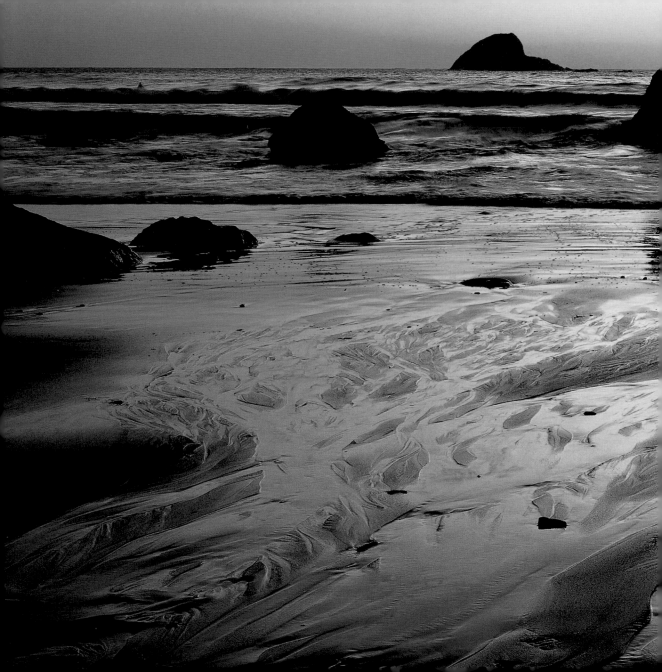

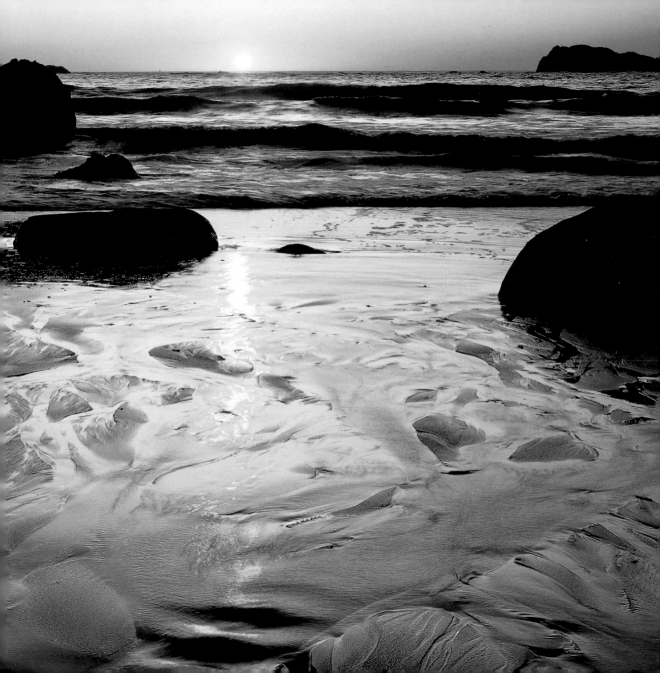

"Come forth into the light of things.

Let Nature be your Teacher."

— William Wordsworth, *The Tables Turned*

Indian Creek in Genesee Valley, northern Sierra Nevada

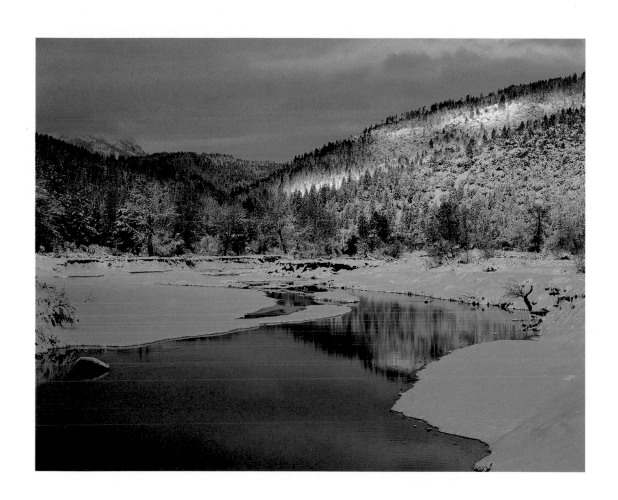

"We need the tonic of wildness…
We can never have enough of nature
We must be refreshed by the sight of inexhaustible vigor,
vast and titanic features…"

— Henry David Thoreau, *Walden*

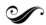

Kaweah Peaks and the Great Western Divide, Sequoia National Park

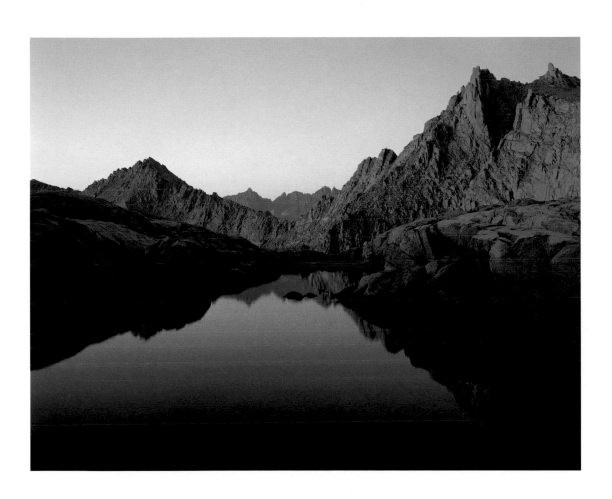

"...And many standing round a waterfall
See one rainbow each, yet not the same to all,
But each a hand's breadth further that the next
The sun on falling waters writes the text..."

— Gerard Manley Hopkins, *At a Welsh Waterfall*

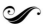

Waterwheel Falls on the Tuolumne River,
Yosemite National Park

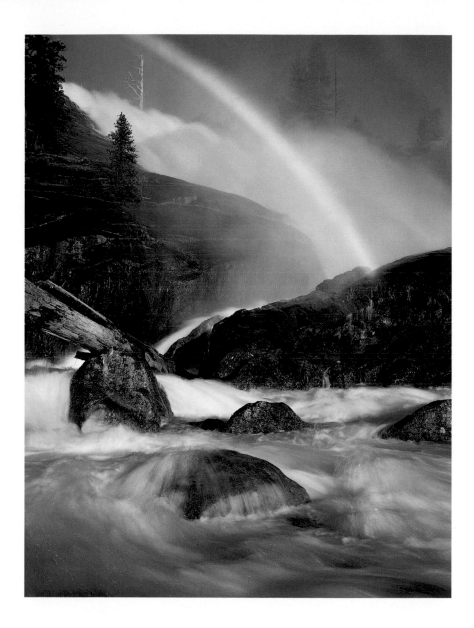

"Let us permit nature to have her way; she understands
her business better than we do."

— Montaigne, *Essays III*

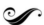

Cattails, Mono Lake

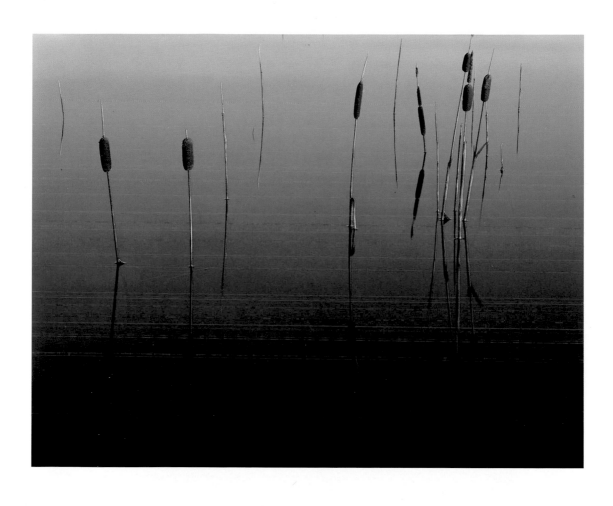

Granite Park, John Muir Wilderness